Simon at the circus

Gilles Tibo

Translated by Sheila Fischman

Tundra Books

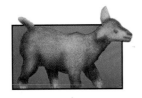

My name is Simon.

I took a cardboard box
and an umbrella,
and I made my own circus!

I call out:
"STEP RIGHT UP! STEP RIGHT UP!
Come and see the incredible tamer
of goats and pigs!"

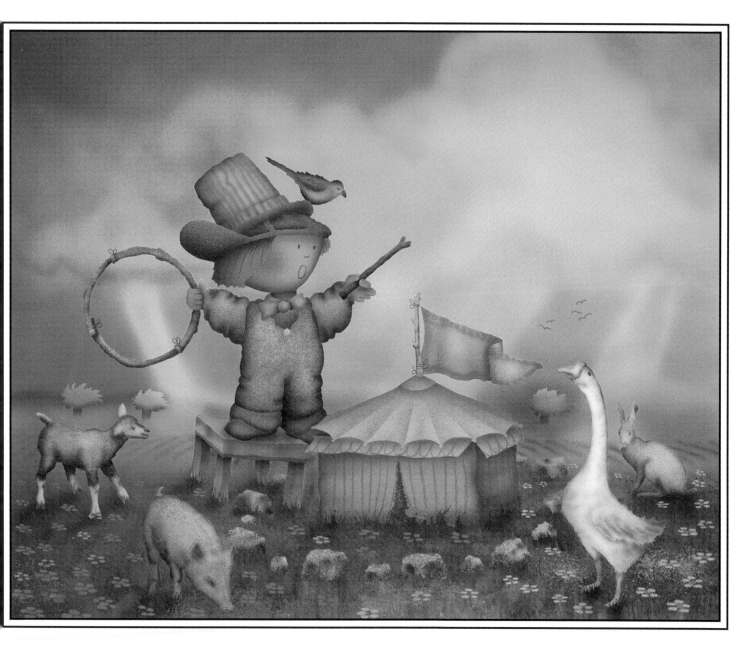

Whoops!
Stop! Stop!

Bing! Bang!
The goats take a run
and bash my circus with their horns.

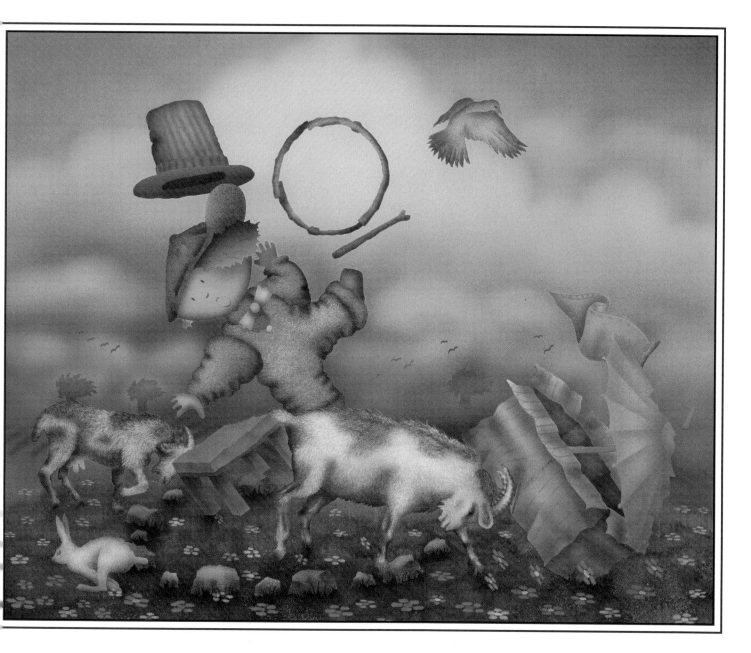

Whoops!
Stop! Stop!

The pigs shove me into the grass.
Scrunch! Scrunch!
They eat the big top,
and they trample my umbrella.

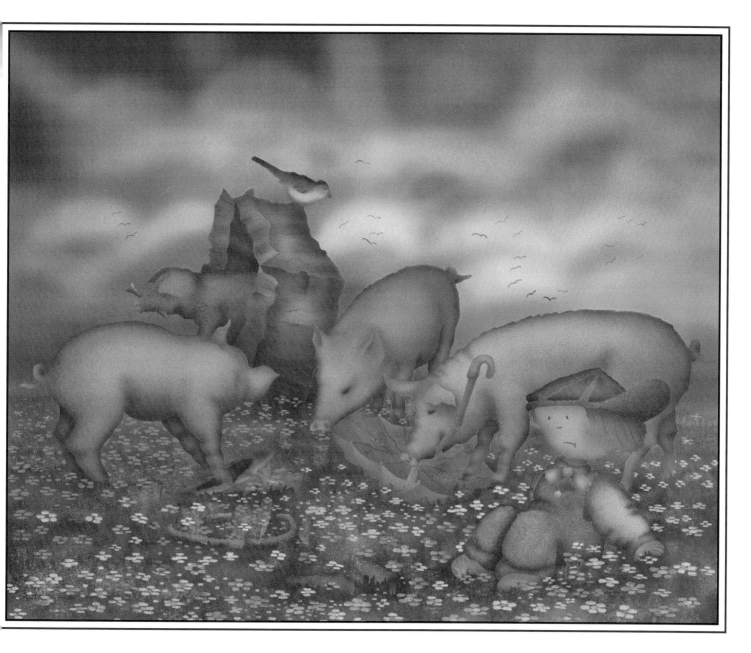

With Marlene watching,
I put on my incredible high-wire act.

Whoops!
Stop! Stop!
Tweet! Tweet! Tweet!

The birds make me lose my balance,
and I fall to the ground.

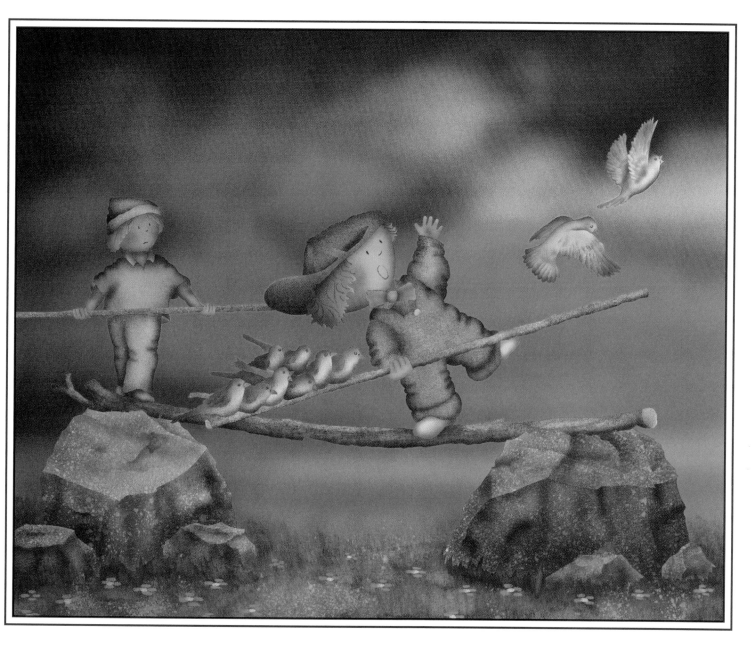

Up on the mountain,
a tall stilt-walker tells me:
"You don't make a circus out of
goats and pigs and sparrows!
You need amazing animals
to dazzle the crowd!"

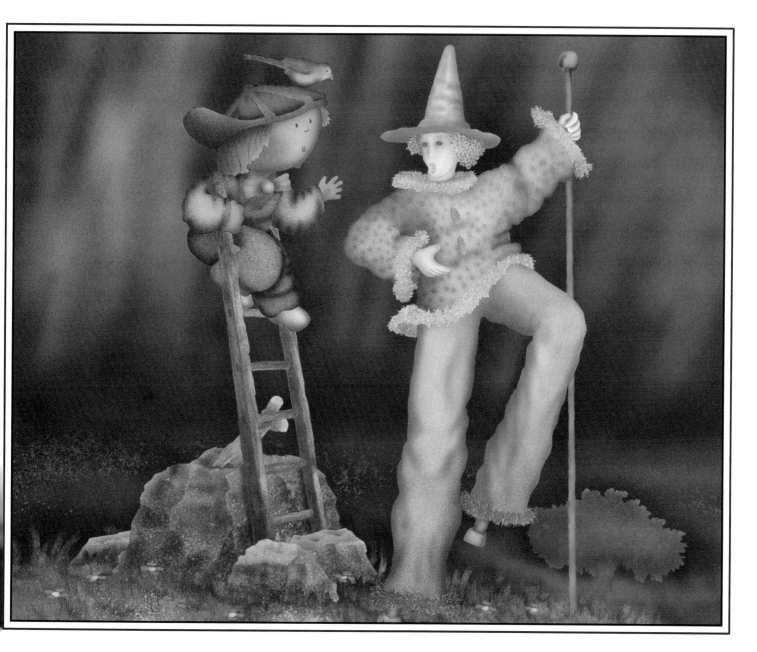

I know what I'll do!
When the moon is shining in the sky,
I'll dress in clothes made of light,
and I'll become
the greatest animal tamer in the world.

Flutter . . . Flutter . . .
I'll make doves fly all around me!

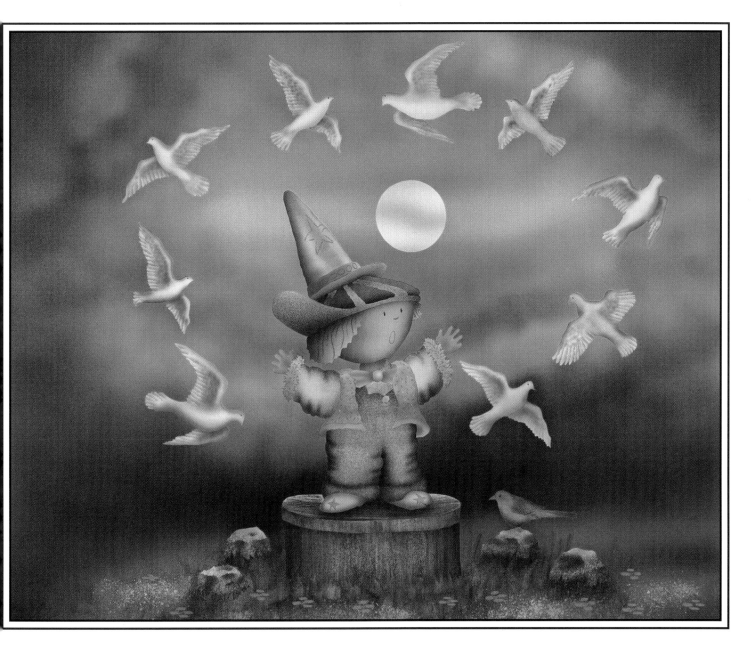

And then,
under the starry sky,
I'll tame the wild beasts:
Grrr! Grrr!
The big fierce tigers
will roar in the night.

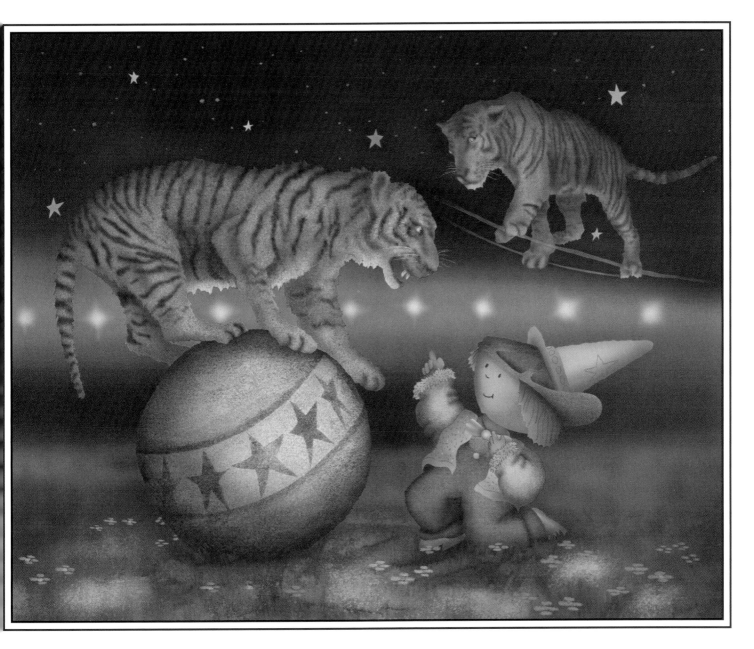

**And then
I'll do
my most amazing act.**

**Yippee!
I'll balance on
an elephant's trunk!**

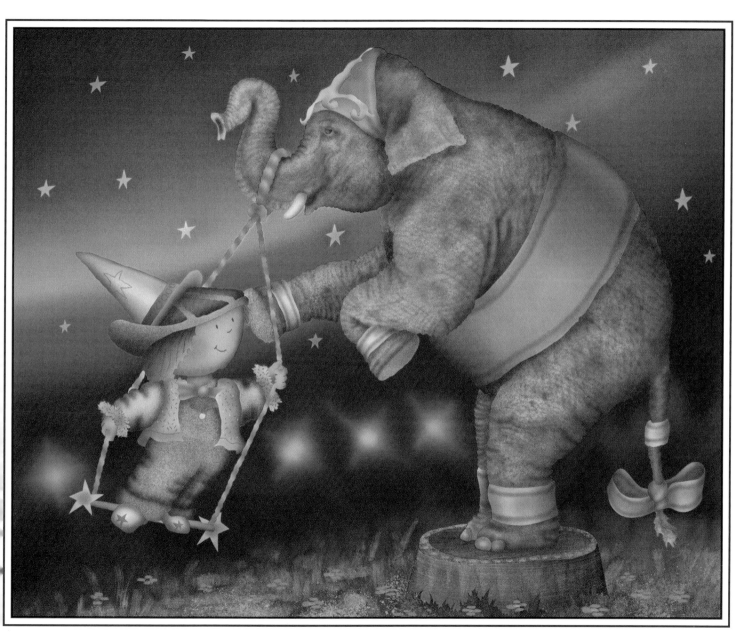

And finally,
under a shower of shooting stars,
swoosh . . . swoosh,
Marlene and I will perform
a dangerous trapeze act.

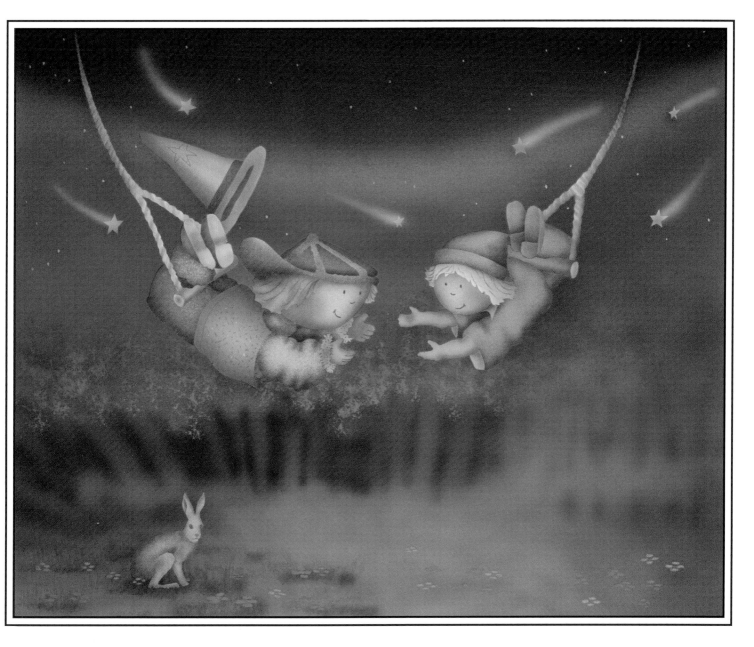

To relax,
I go to the mountain
and look at the sky.

After thinking it over,
I tell my little bird:
"Whee!
I've just had a great idea!"

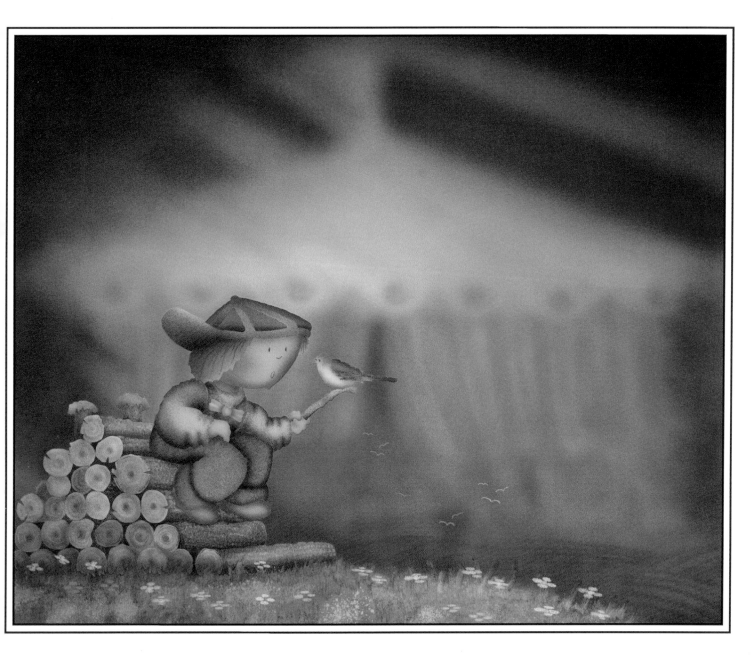

I go into the forest
where I join Marlene and all my friends.
And together, we all play circus.

With paper and cardboard,
we make a bear, a lion,
elephants, a giraffe, a snake.

And I call out:
"STEP RIGHT UP! STEP RIGHT UP!
Come and see the finest circus in the world!"

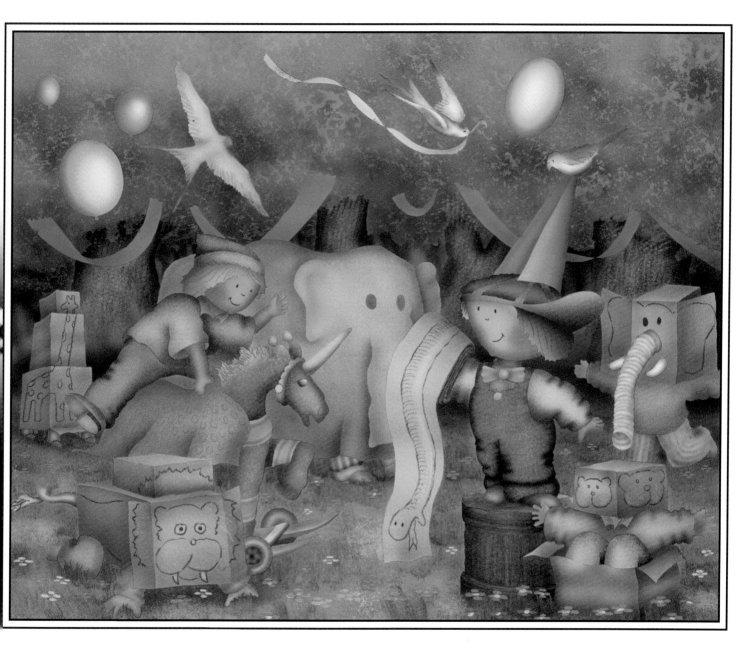

For Geneviève

© **1997 Gilles Tibo**: text and illustrations
© **1997 Sheila Fischman**: English translation

Published in Canada by Tundra Books, *McClelland & Stewart Young Readers*,
481 University Avenue, Toronto, Ontario M5G 2E9

Published in the United States by Tundra Books of Northern New York,
P.O. Box 1030, Plattsburgh, New York 12901

Library of Congress Catalog Number: 97-60510

Canadian Cataloguing in Publication Data

Tibo, Gilles, 1951-
 [Simon et le petit cirque. English]
 Simon at the circus

Issued also in French under title: Simon et le petit cirque.
ISBN 0-88776-414-2 (bound) ISBN 0-88776-416-9 (pbk.)

I. Title. II. Title: Simon et le petit cirque. English.

PS8589.I26S528313 1997 jC843'.54 C97-930716-3
PZ7.T4333Sic

We acknowledge the support of the Canada Council for the Arts for our publishing program.

Printed and bound in Canada

1 2 3 4 5 6 02 01 00 99 98 97